Color My Patterns

LOUISE ATHERTON

COLOR MY PATTERNS

2017 Louise Atherton
louiseathertoncoloring.wordpress.com

All rights reserved.

ISBN: 1545107254
ISBN-13: 978-1545107256

COLOR MY PATTERNS

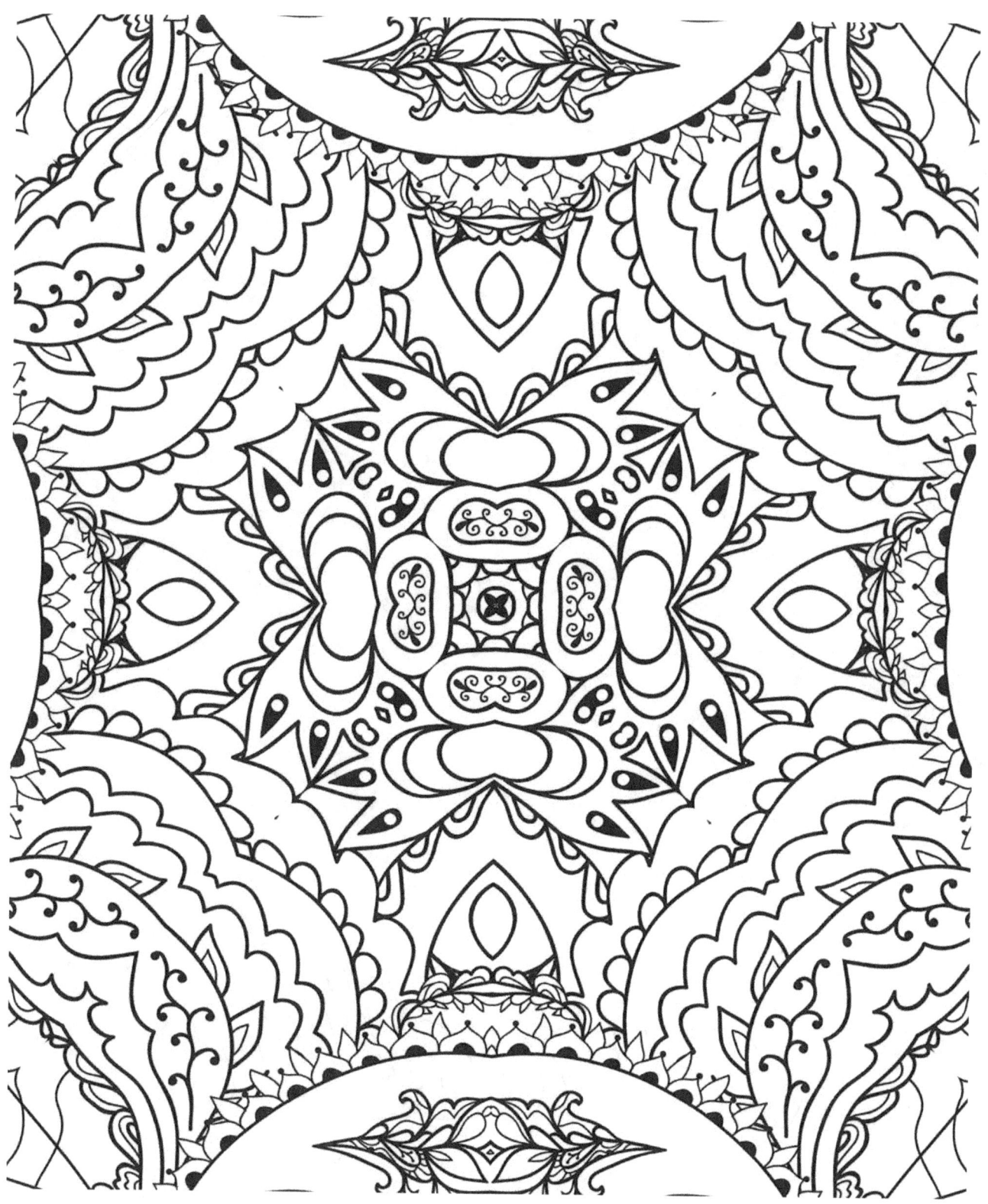

LOUISE ATHERTON

Mindful

COLOR MY PATTERNS

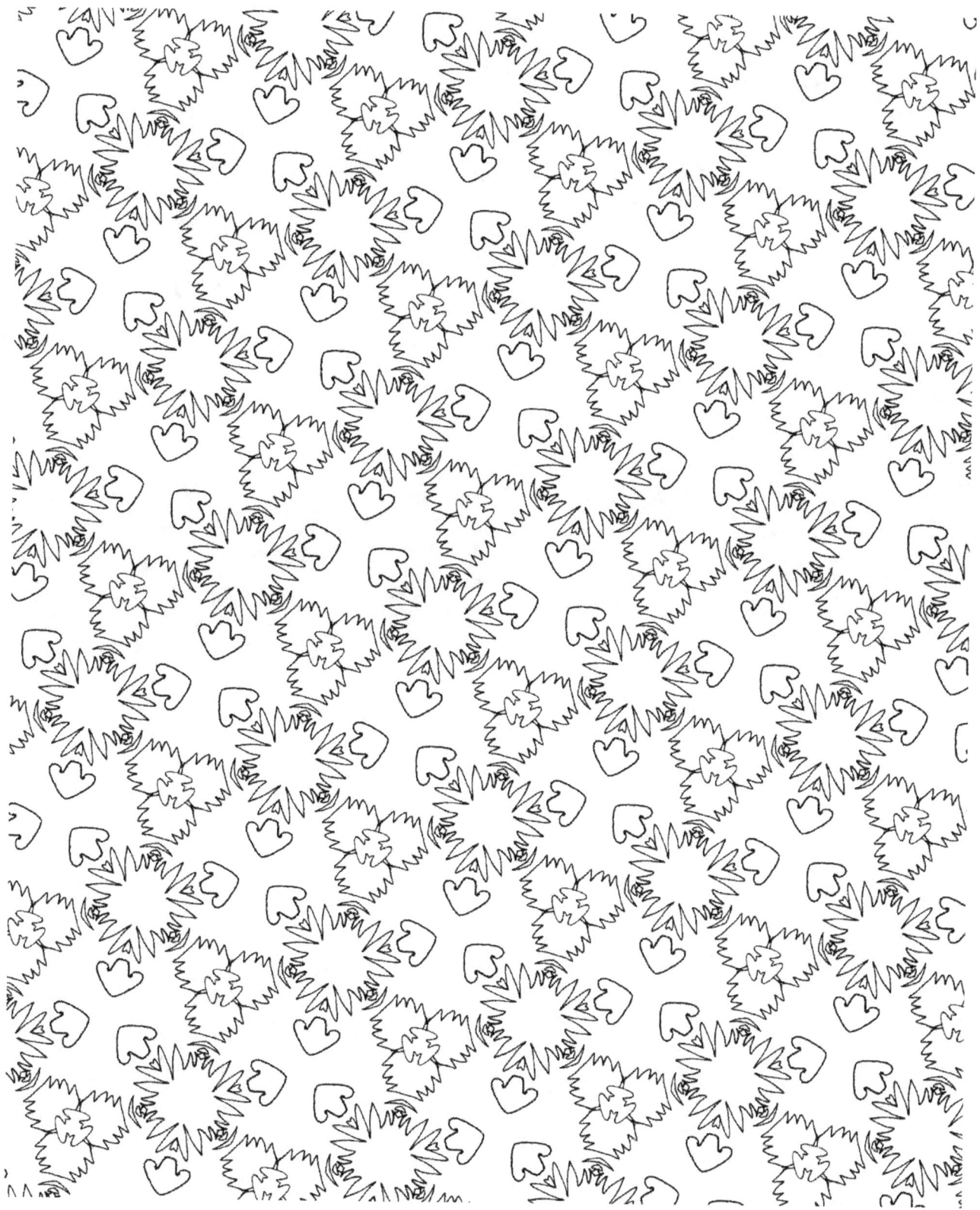

Thoughts

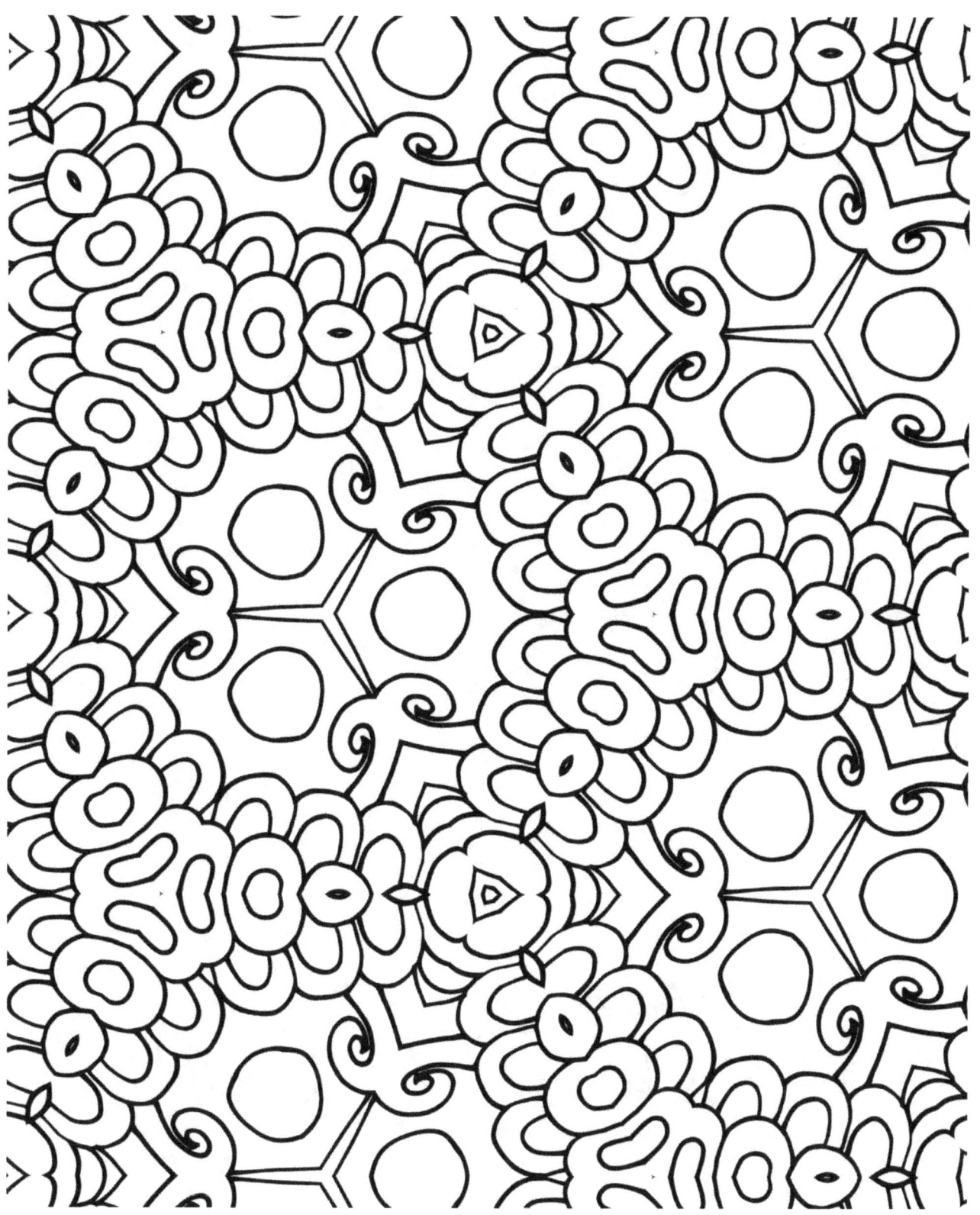

LOUISE ATHERTON

COLOR MY PATTERNS

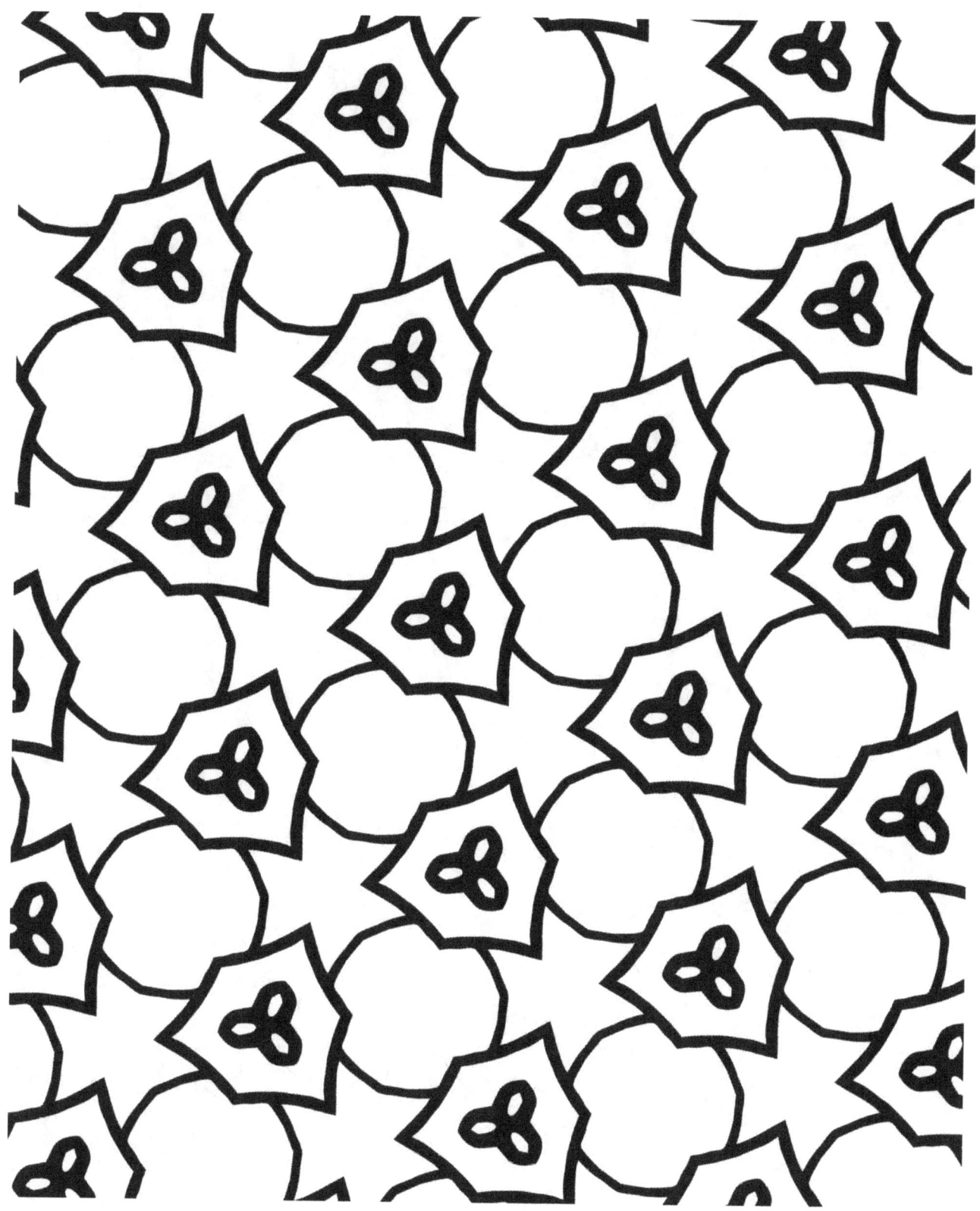

LOUISE ATHERTON

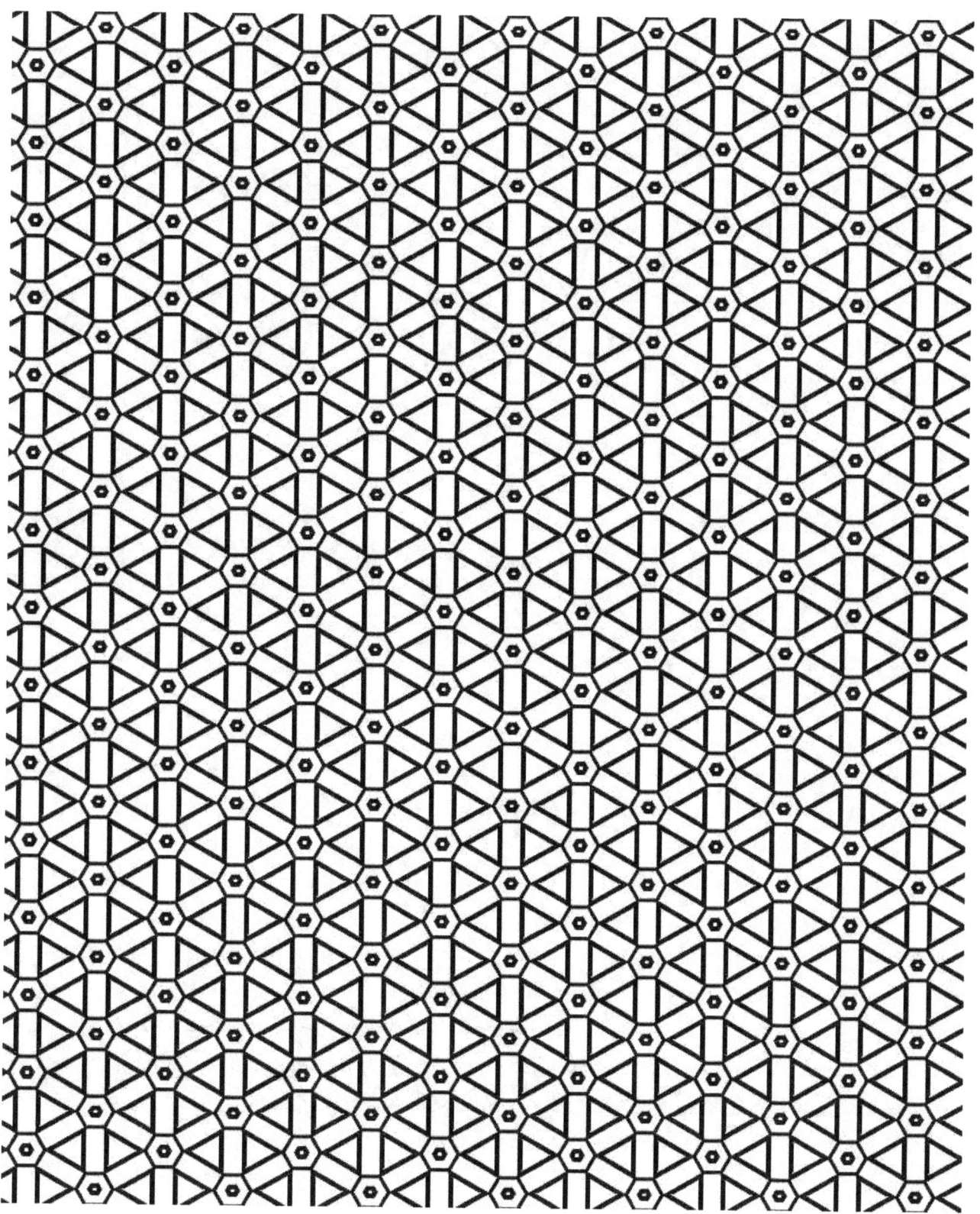

LOUISE ATHERTON

Kindness

COLOR MY PATTERNS

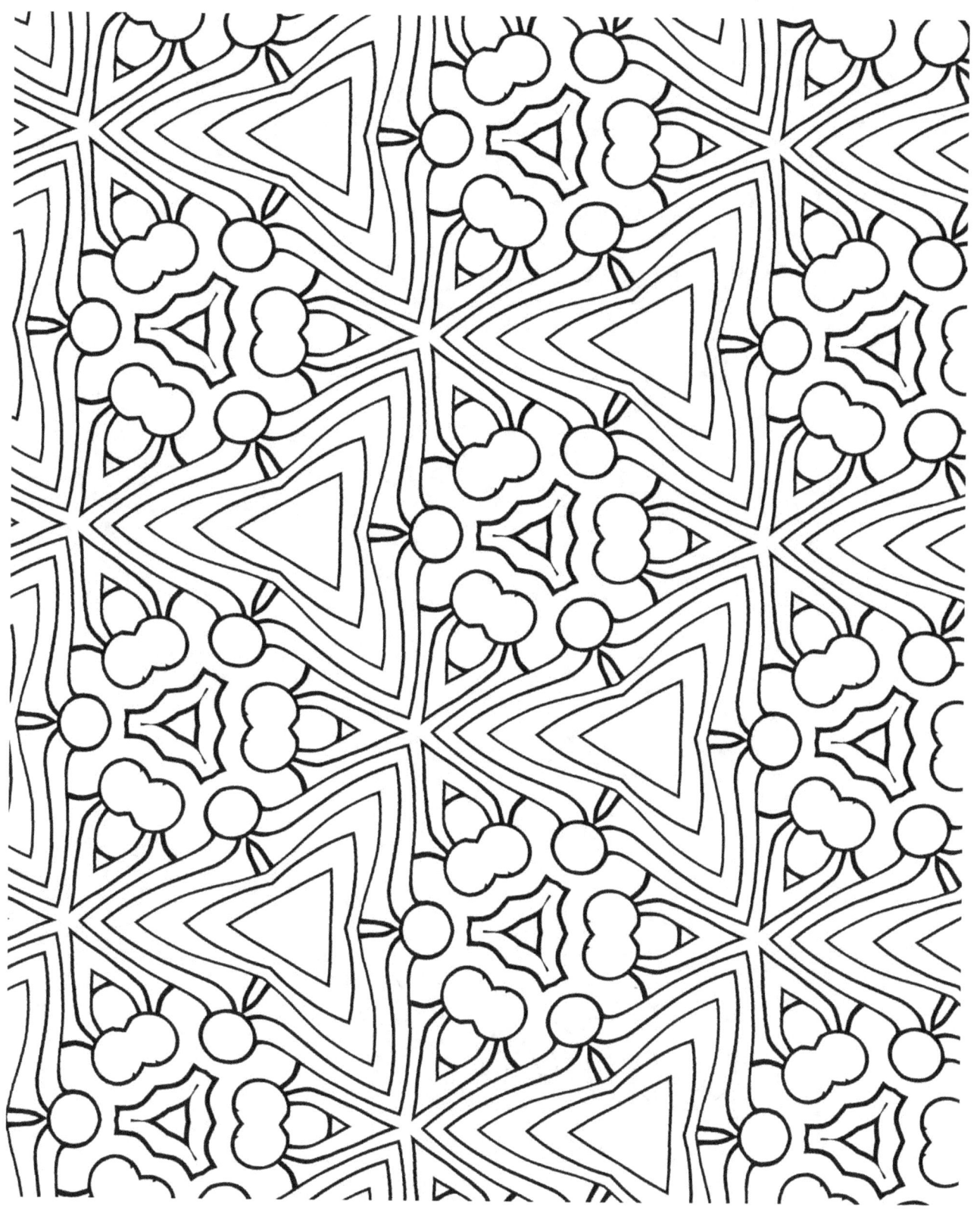

LOUISE ATHERTON

COLOR MY PATTERNS

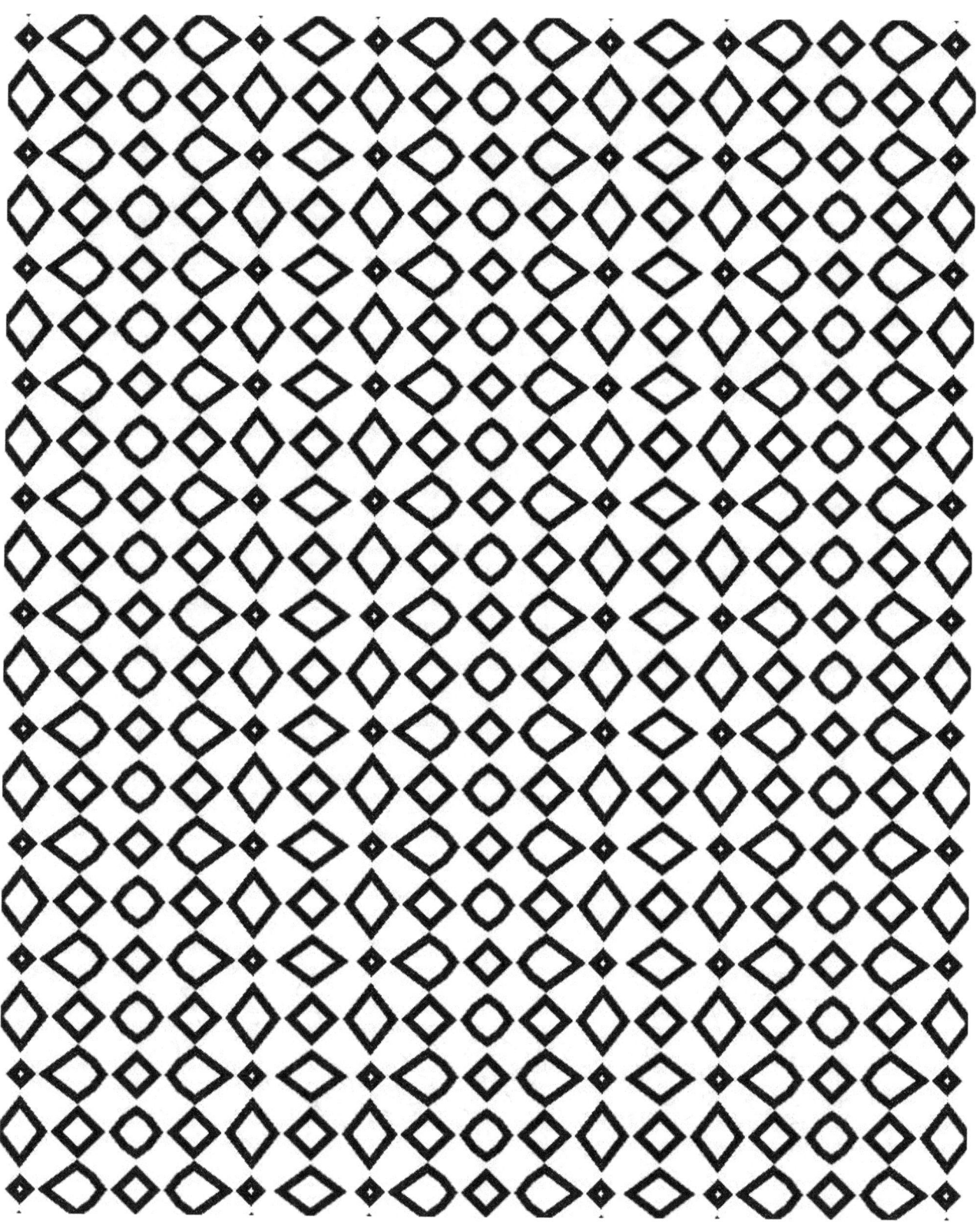

COLOR MY PATTERNS

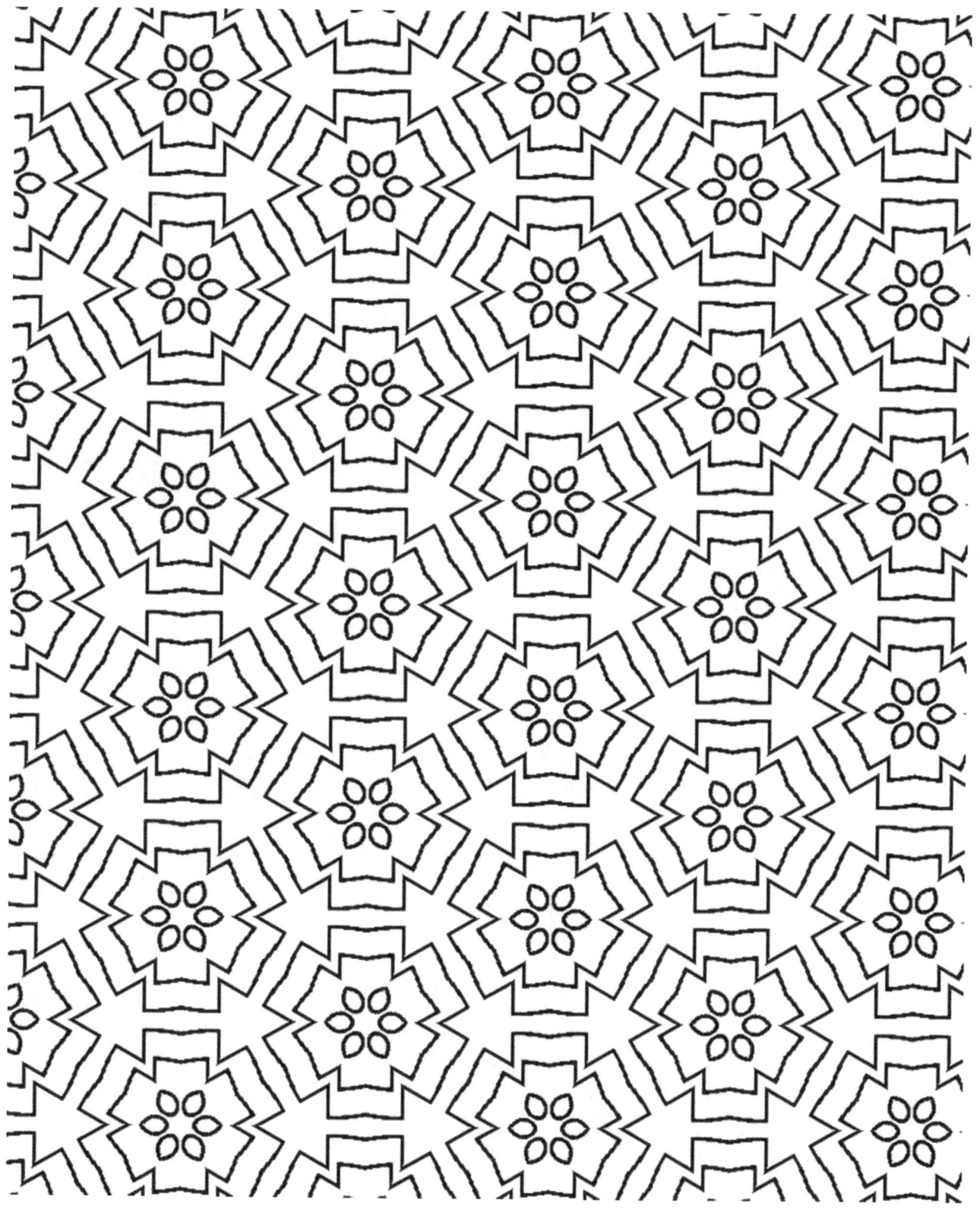

LOUISE ATHERTON

COLOR MY PATTERNS

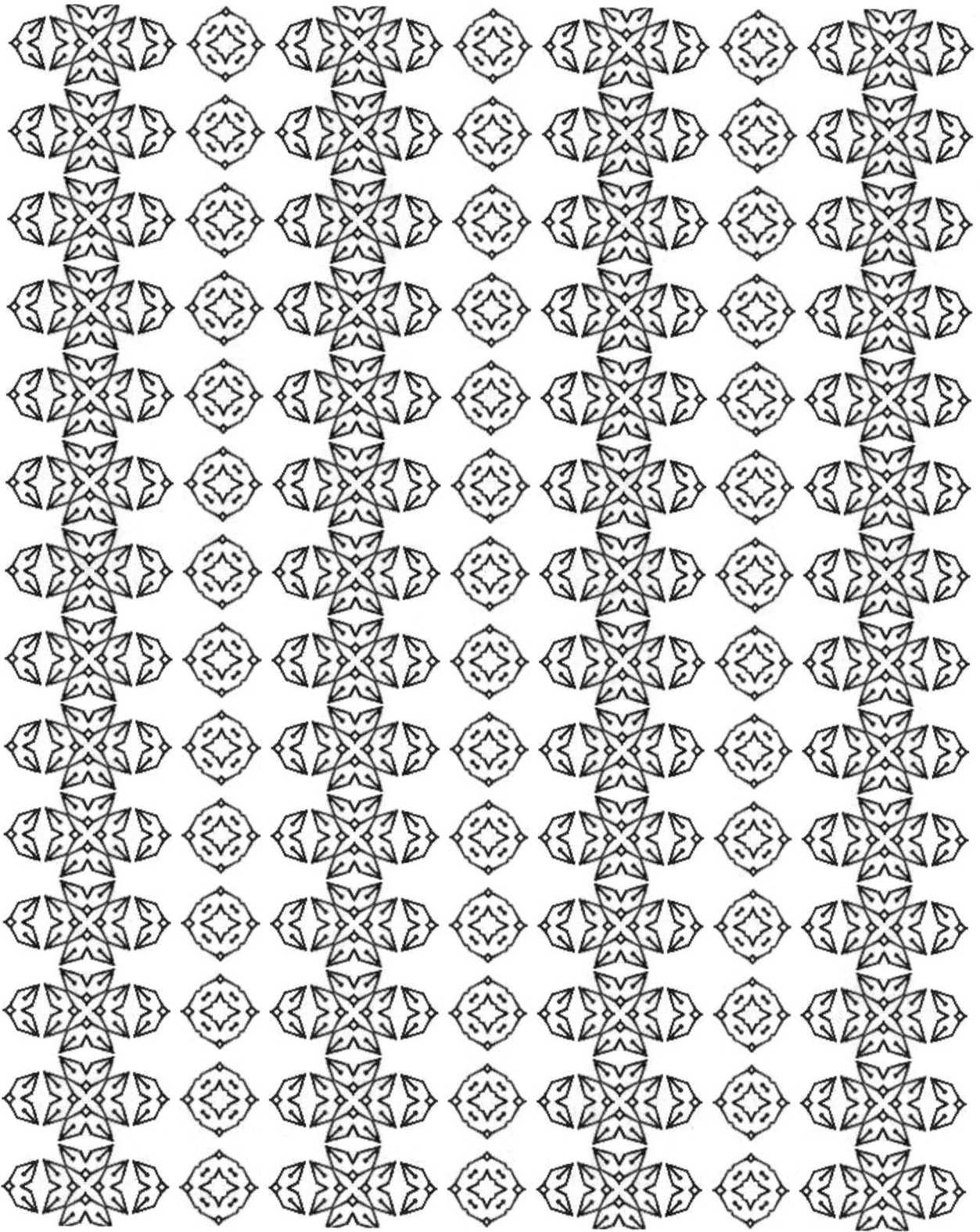

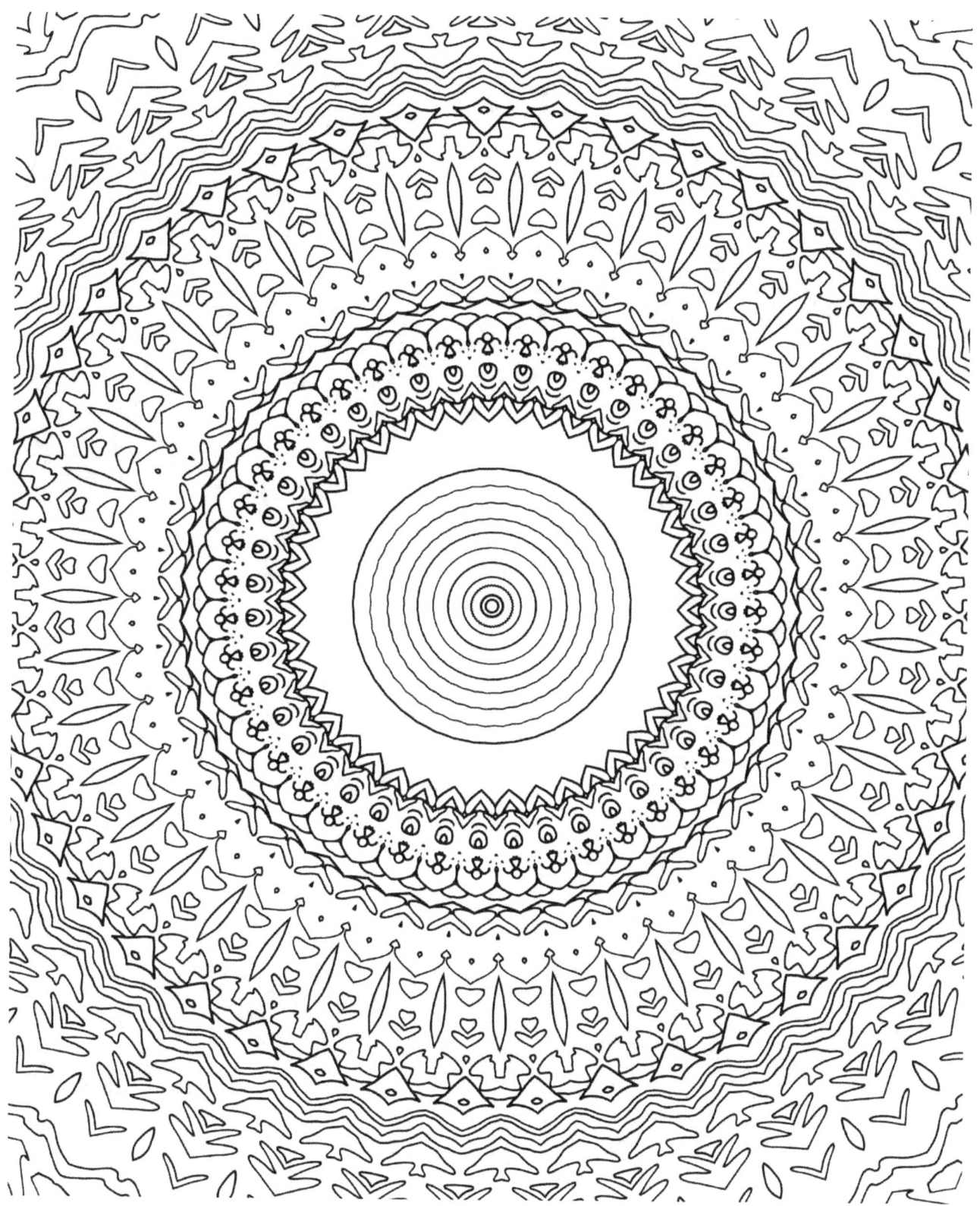

LOUISE ATHERTON

Deliberation

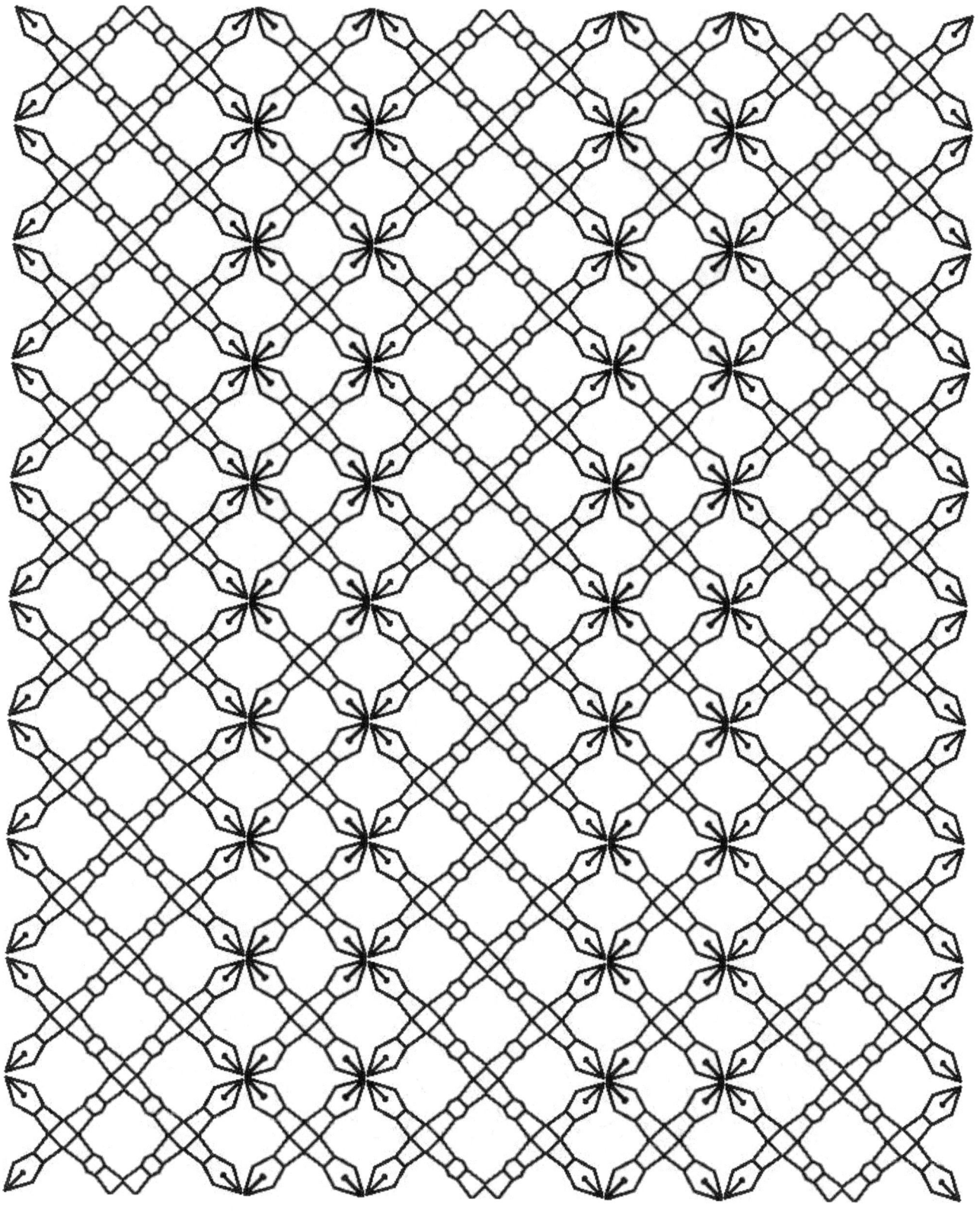

Friendship

COLOR MY PATTERNS

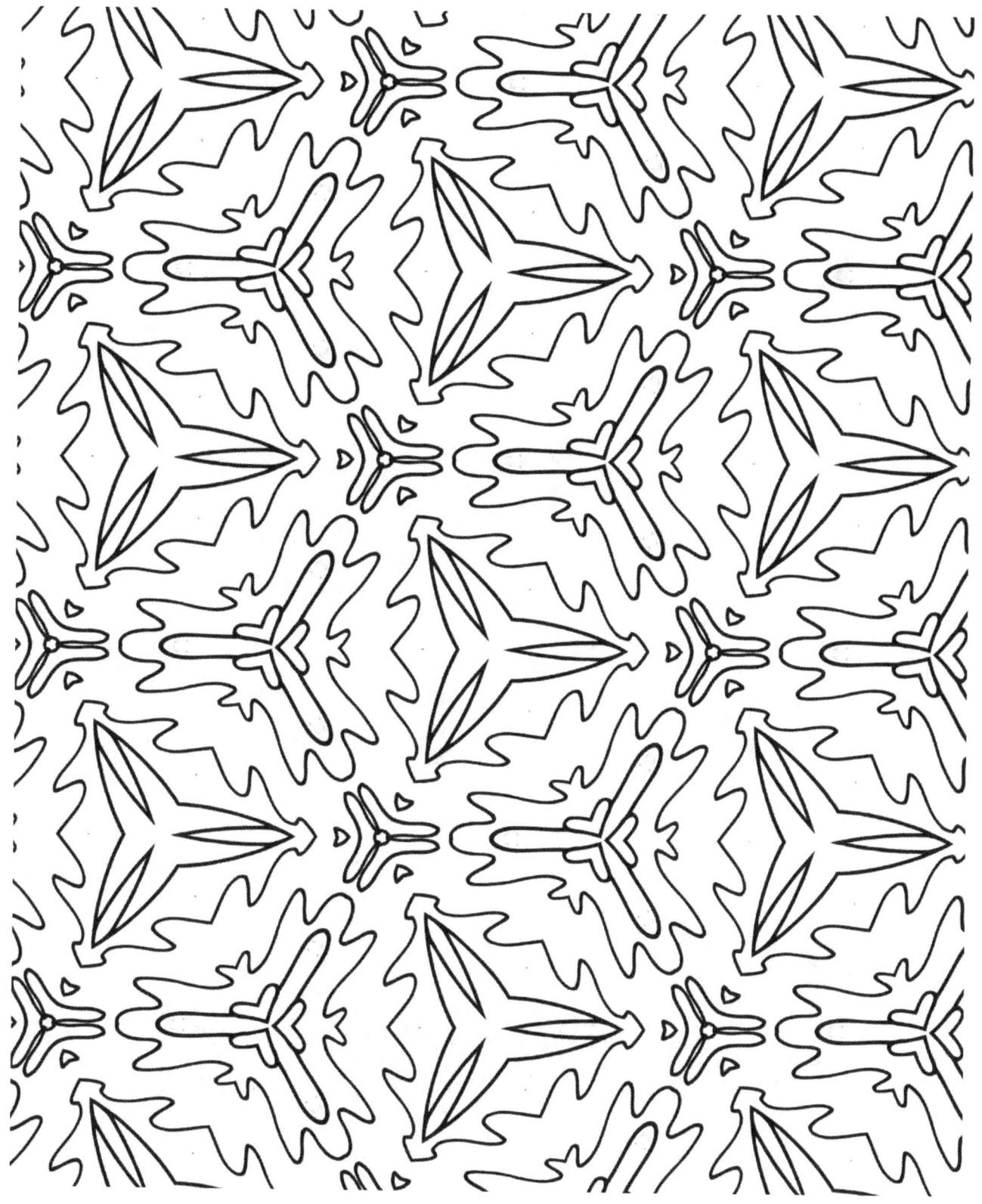

COLOR MY PATTERNS

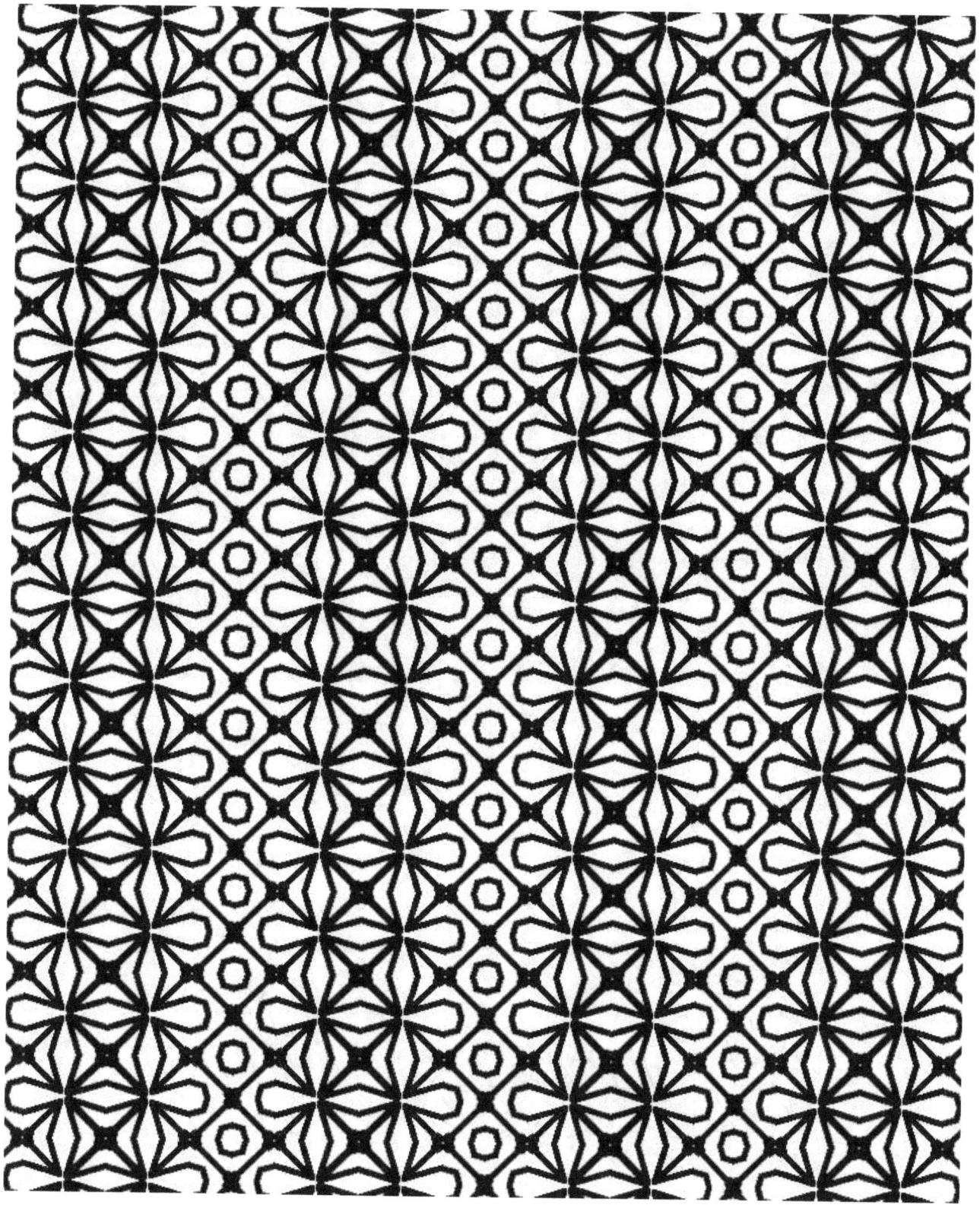

COLOR MY PATTERNS

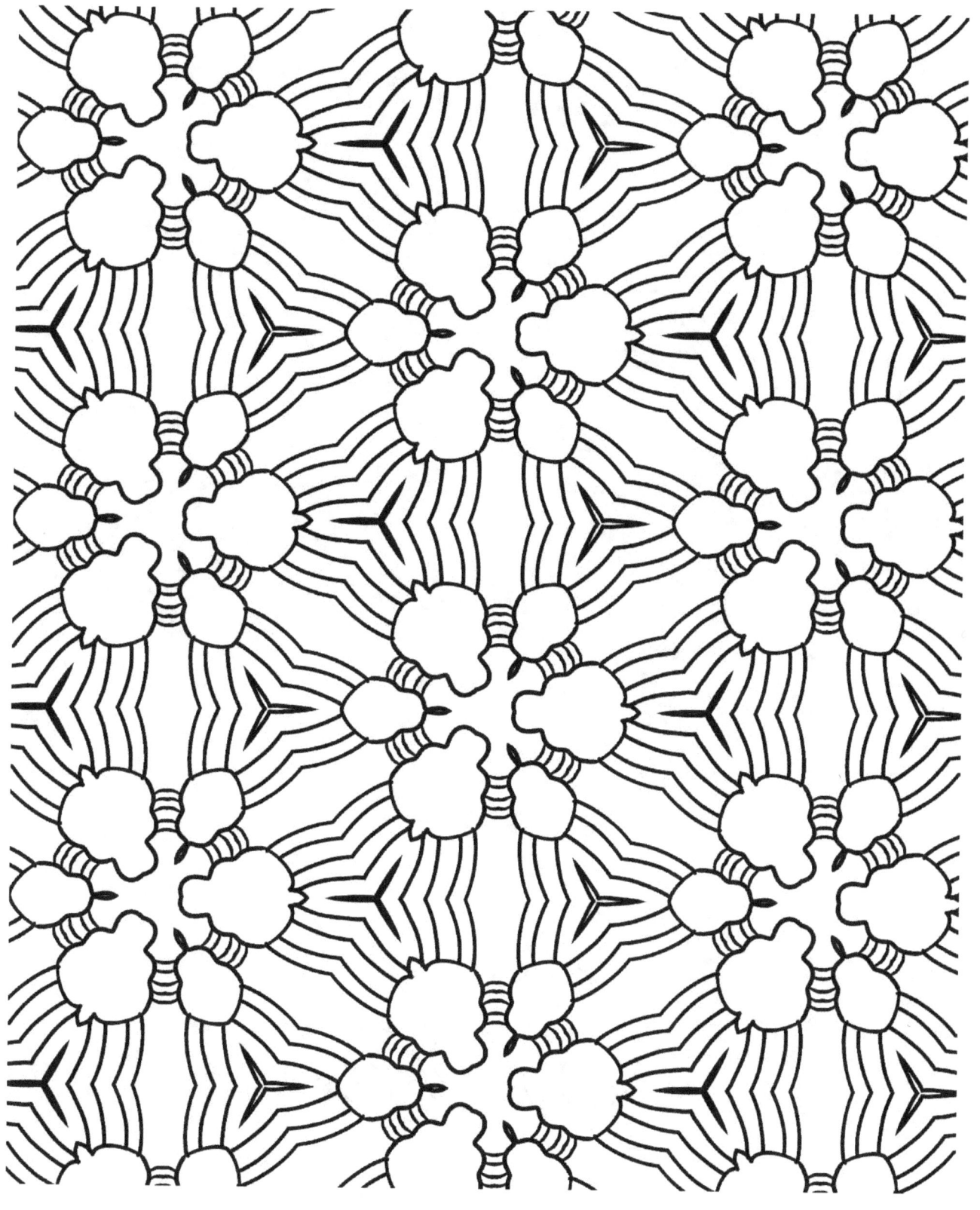

LOUISE ATHERTON

COLOR MY PATTERNS

LOUISE ATHERTON

Indulgence

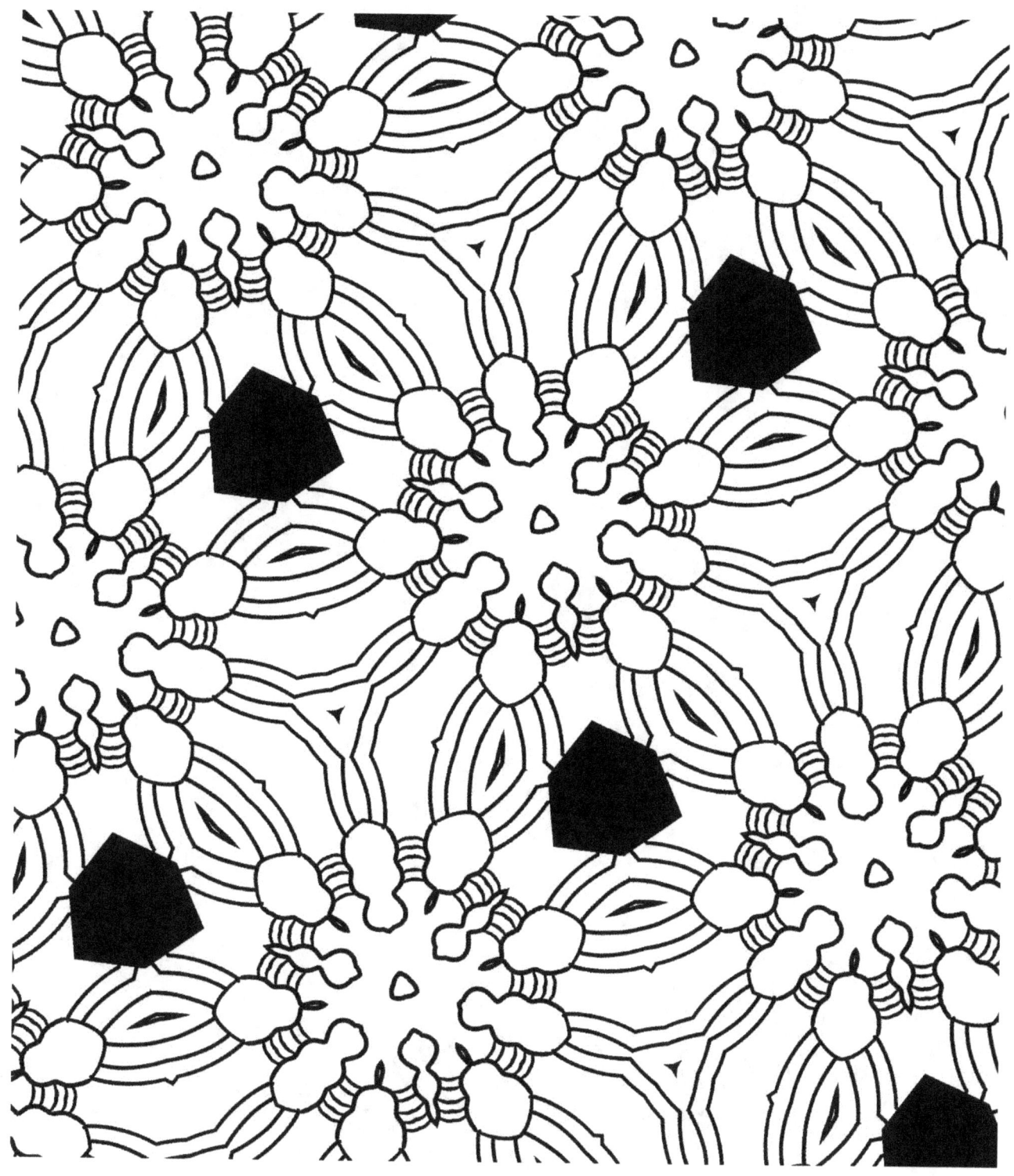

LOUISE ATHERTON

Observe

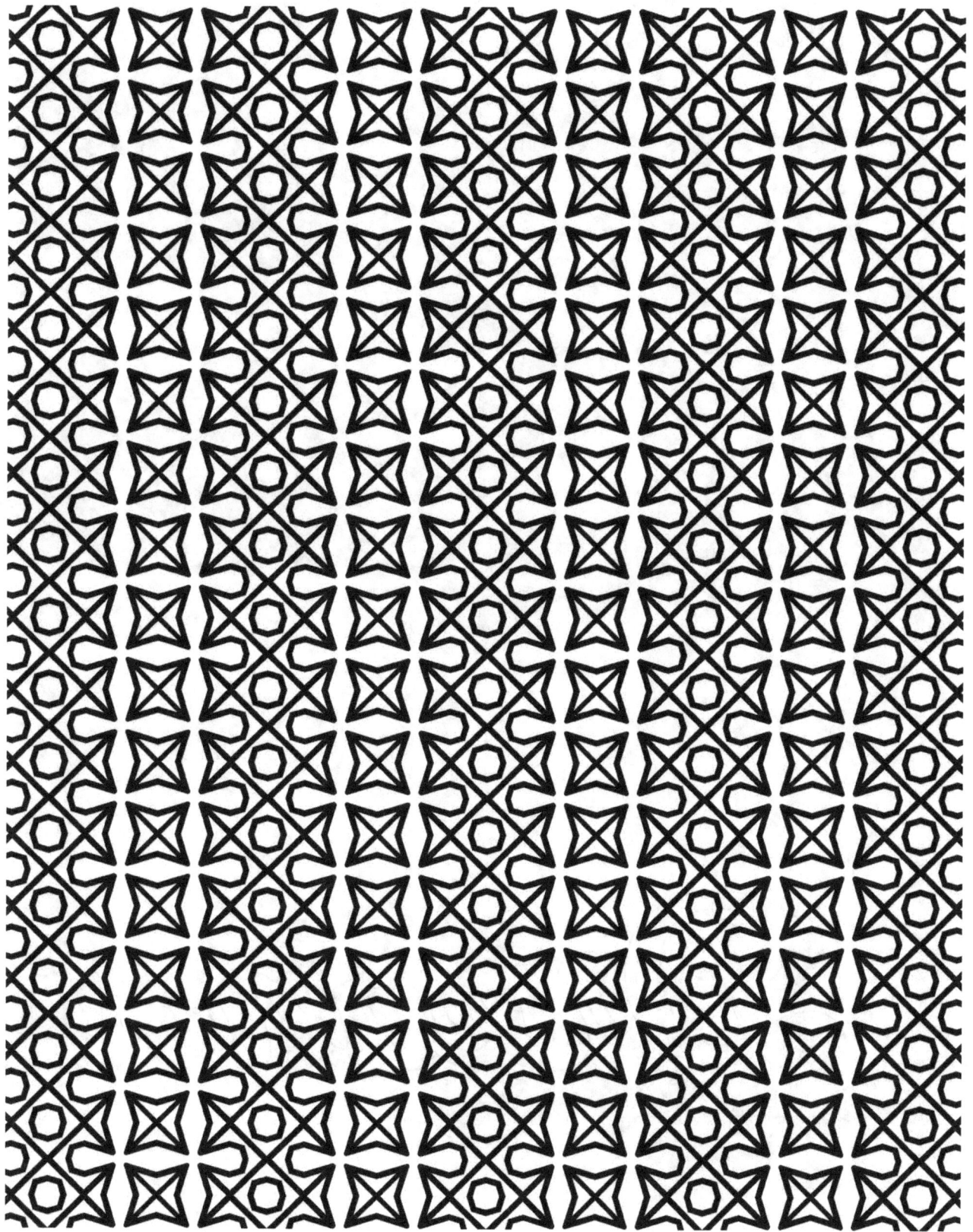

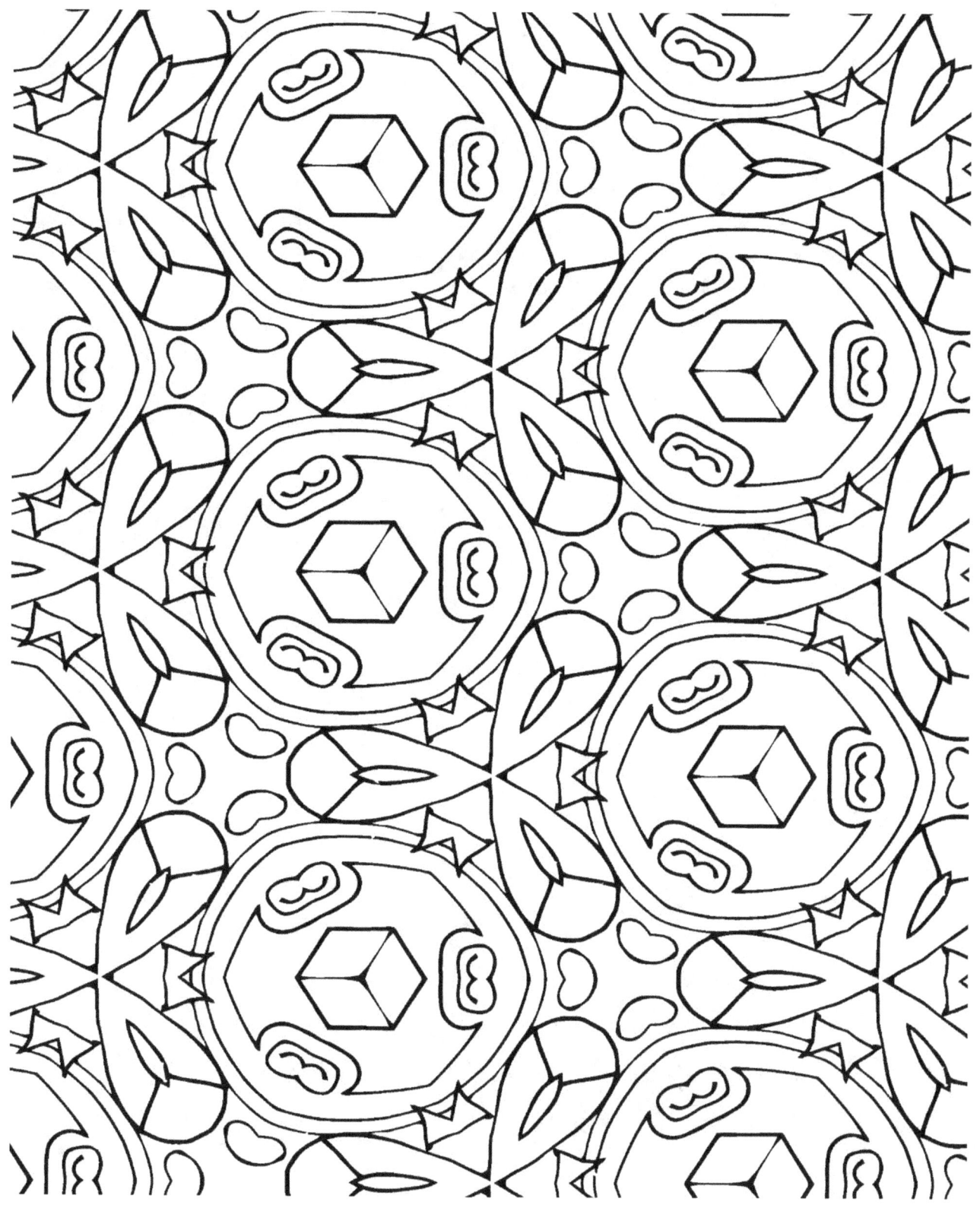

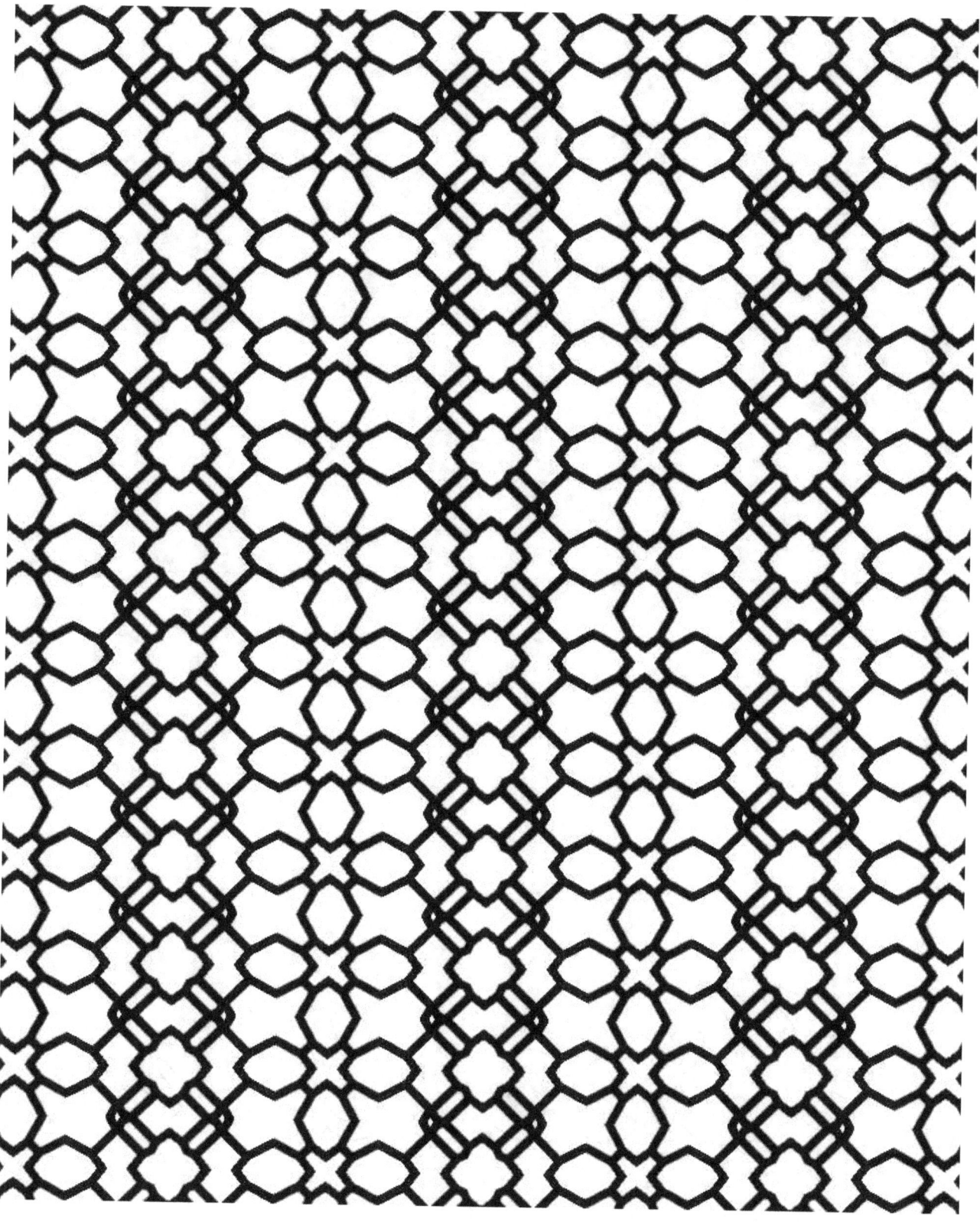

Breathe

COLOR MY PATTERNS

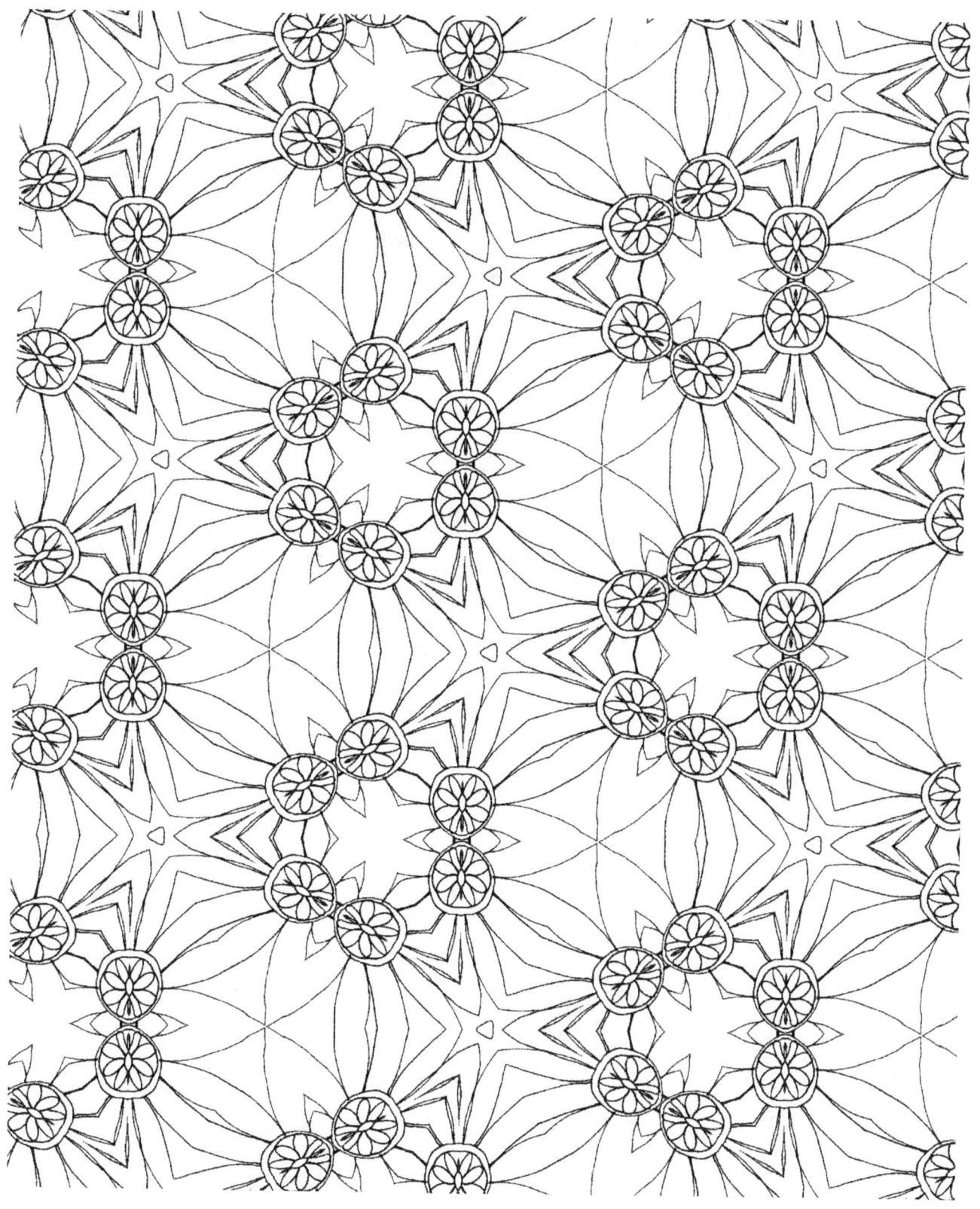

LOUISE ATHERTON

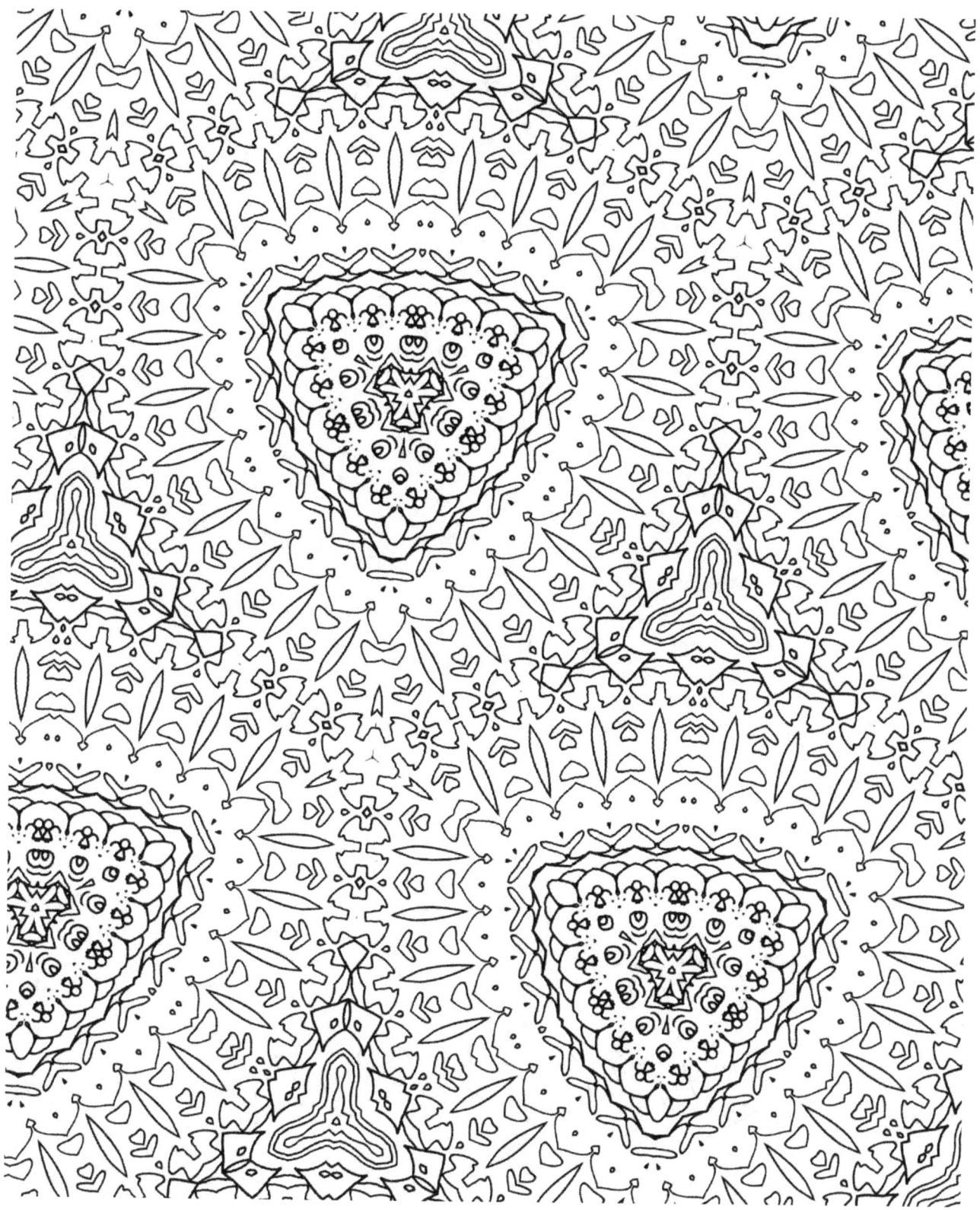

LOUISE ATHERTON

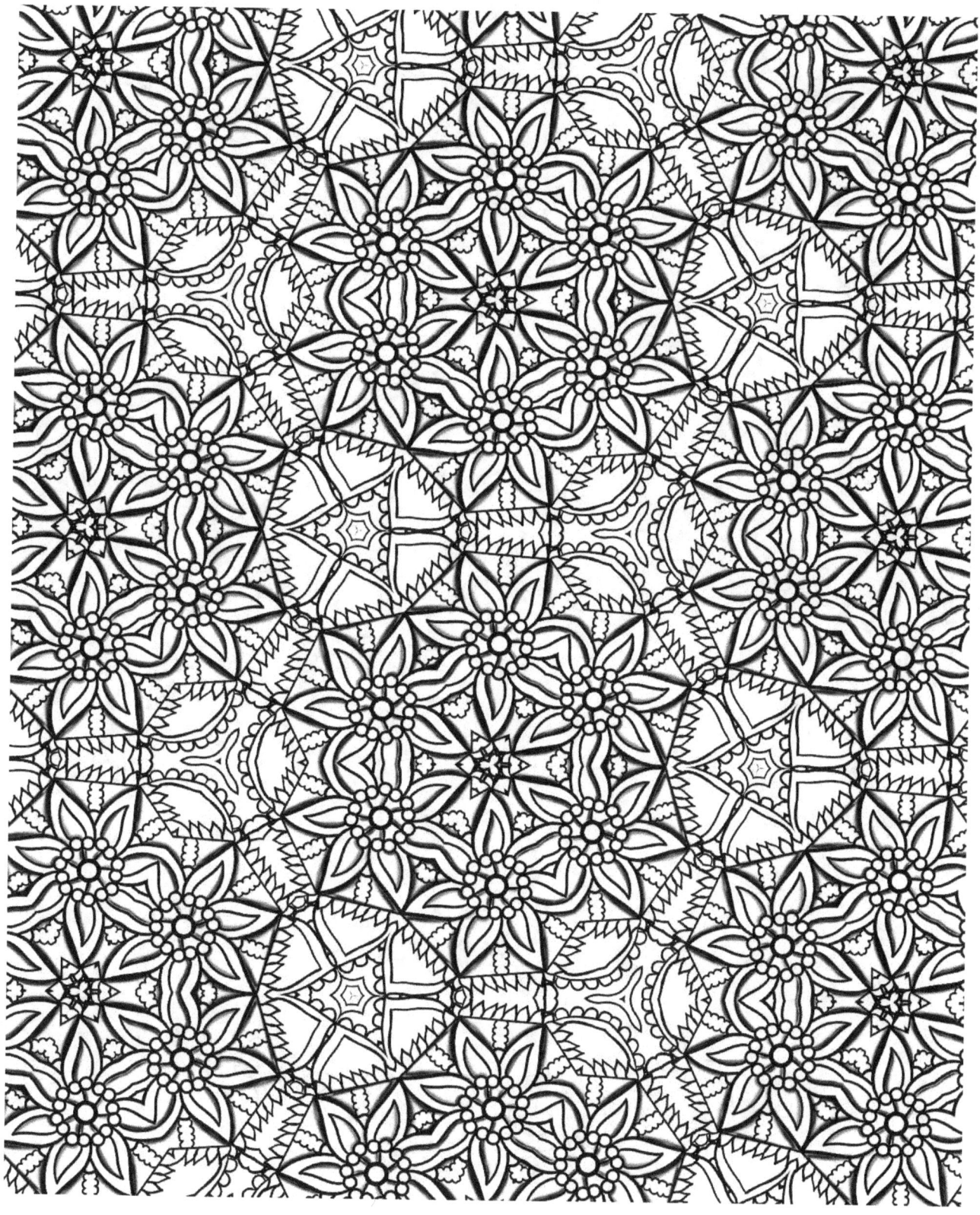

LOUISE ATHERTON

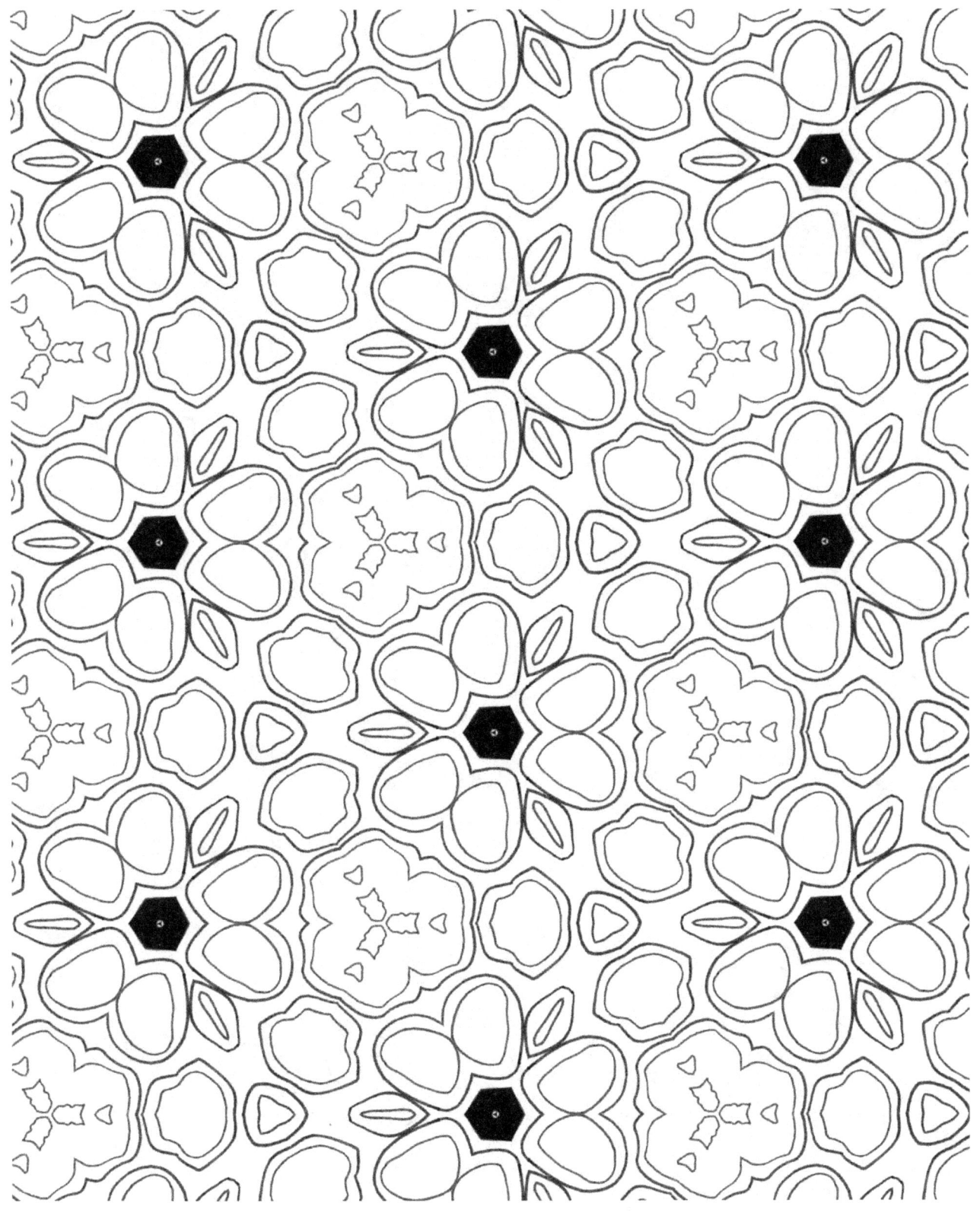

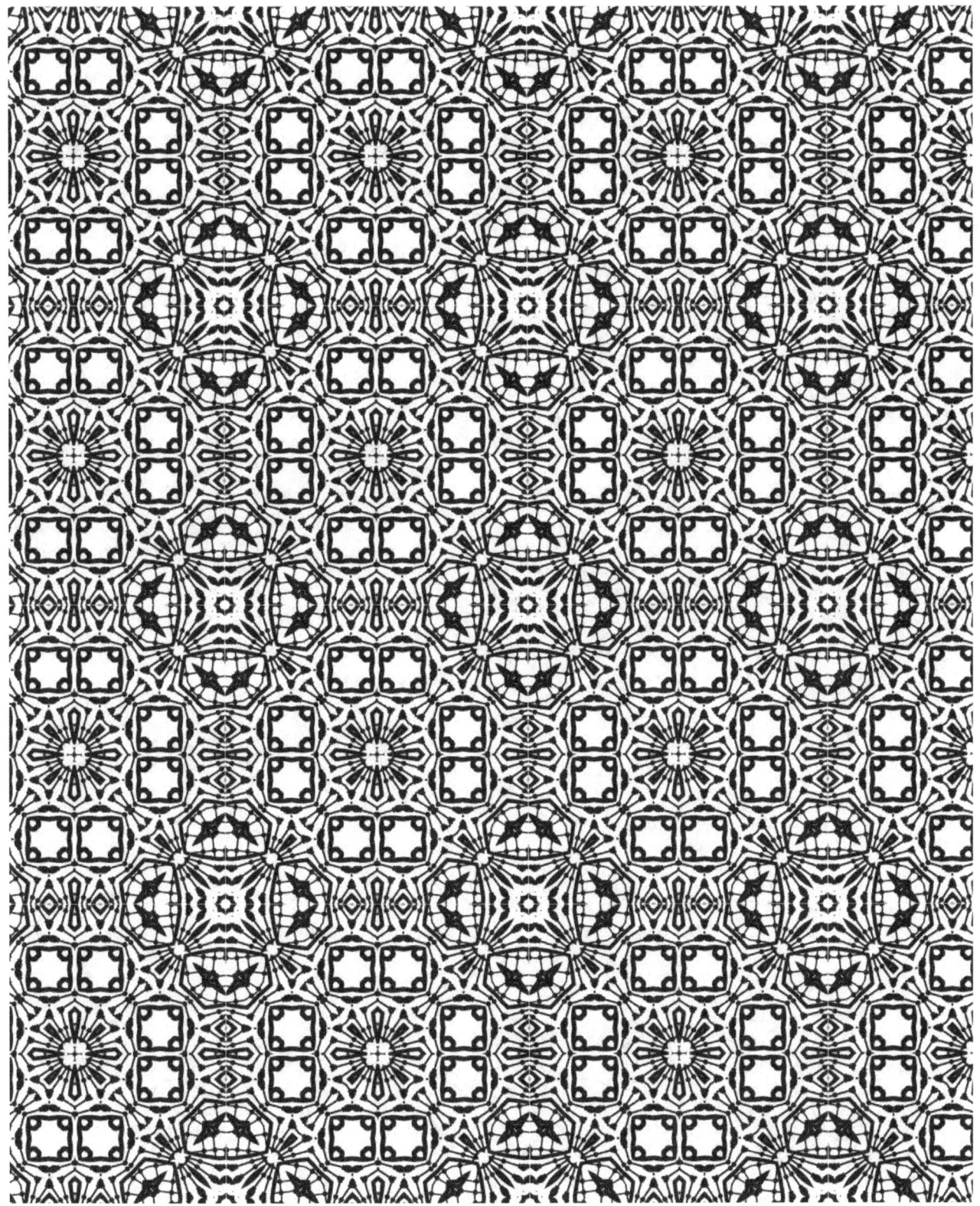

Tolerance

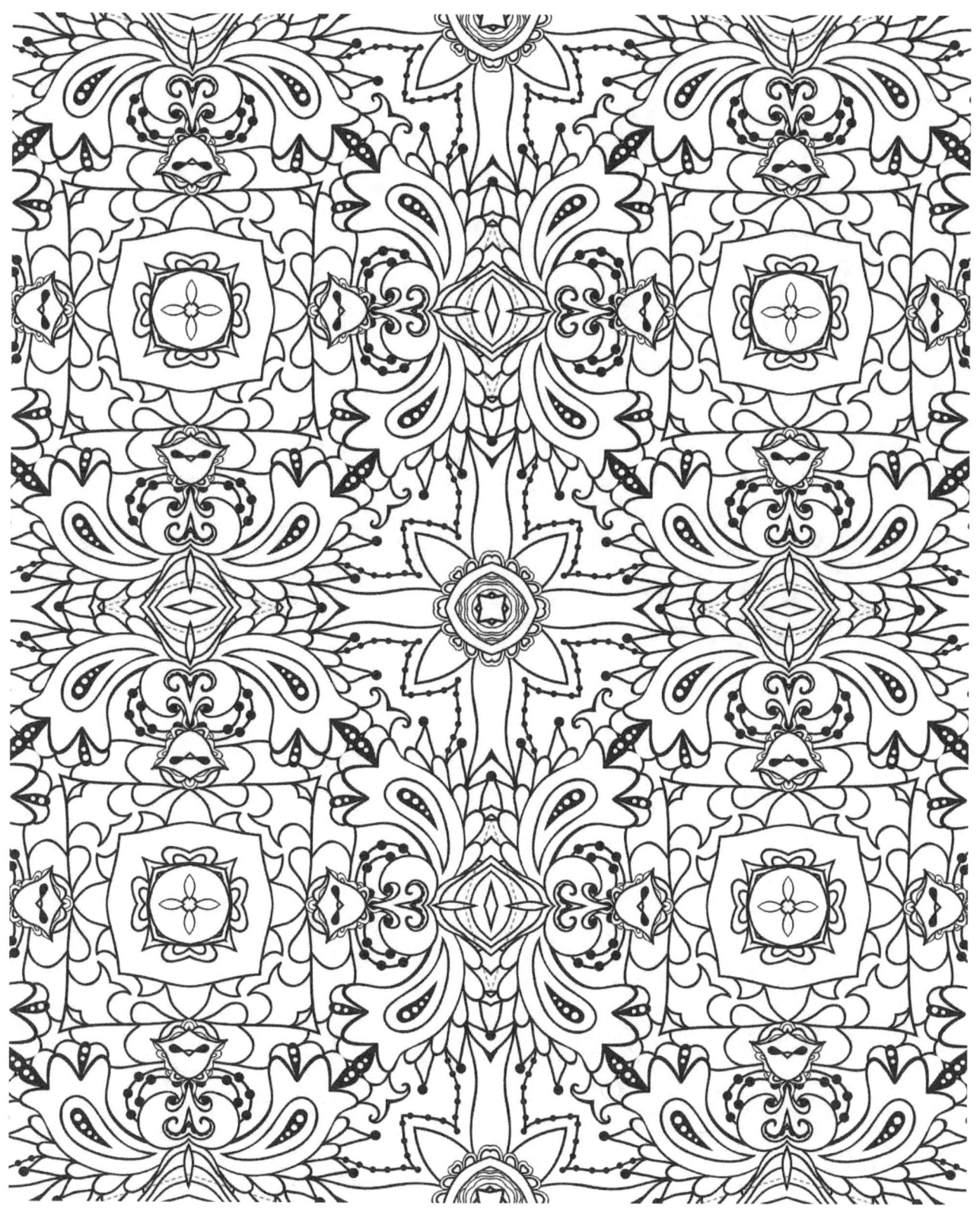

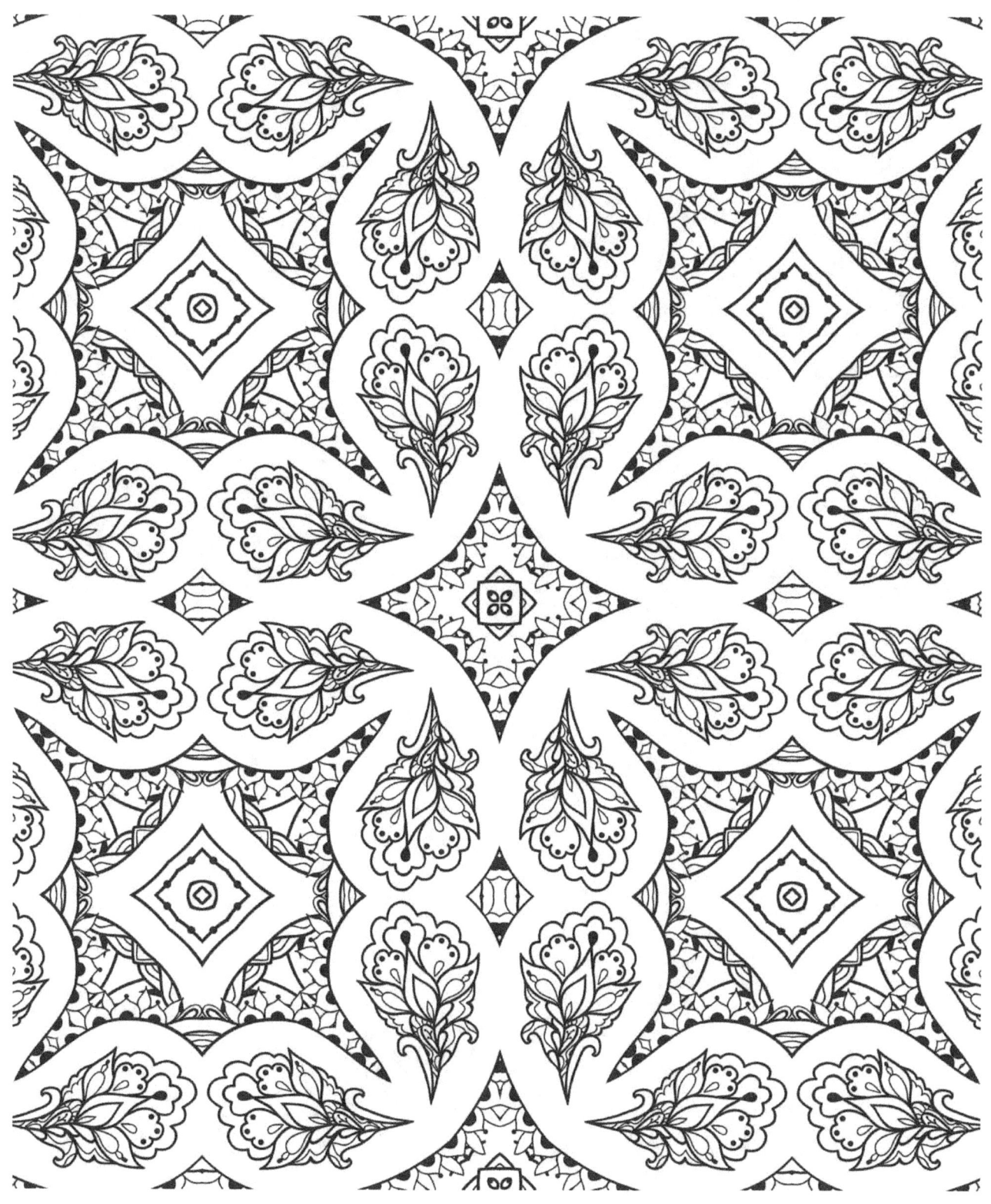

Nostalgia

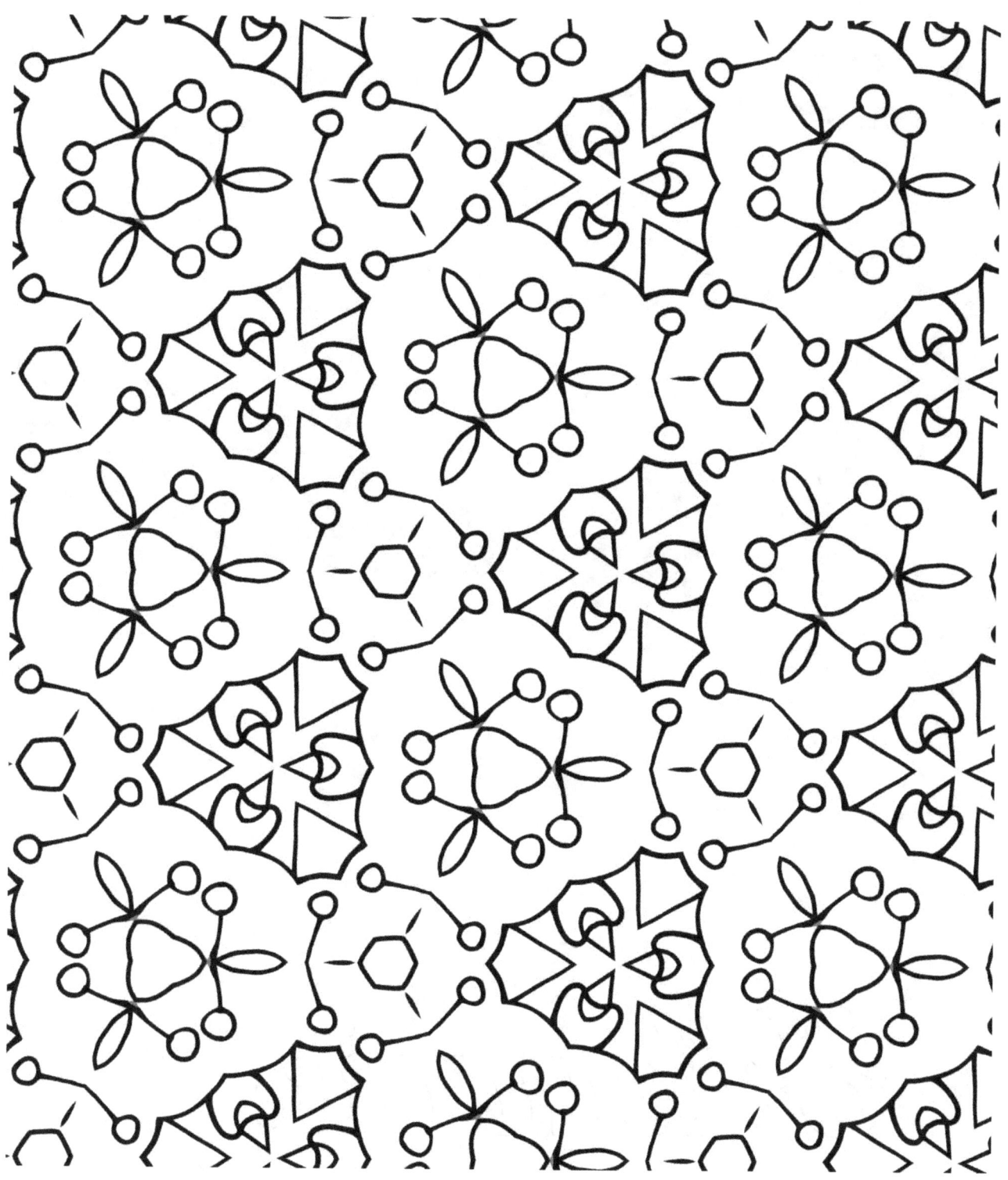

Planning

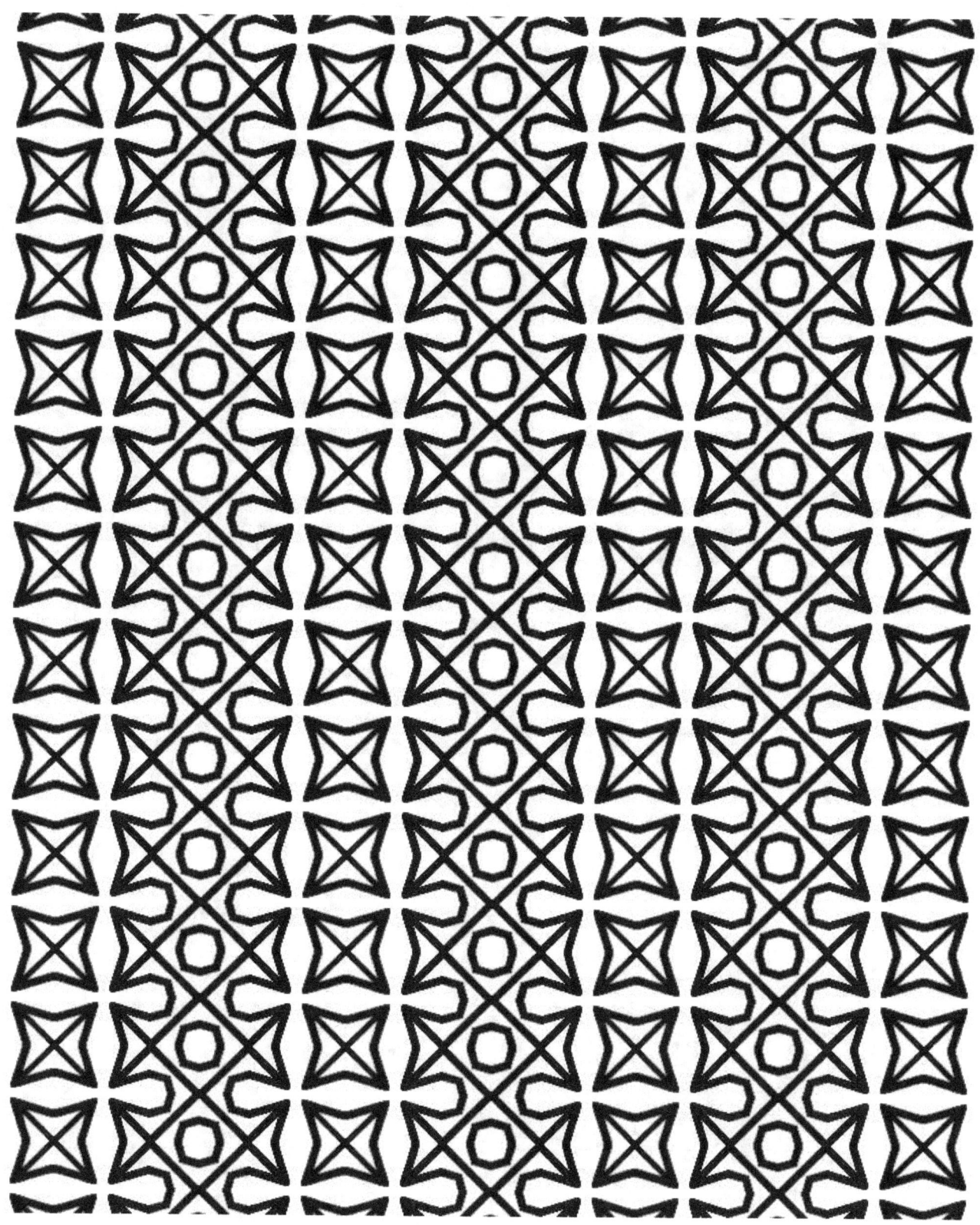

COLOR MY PATTERNS